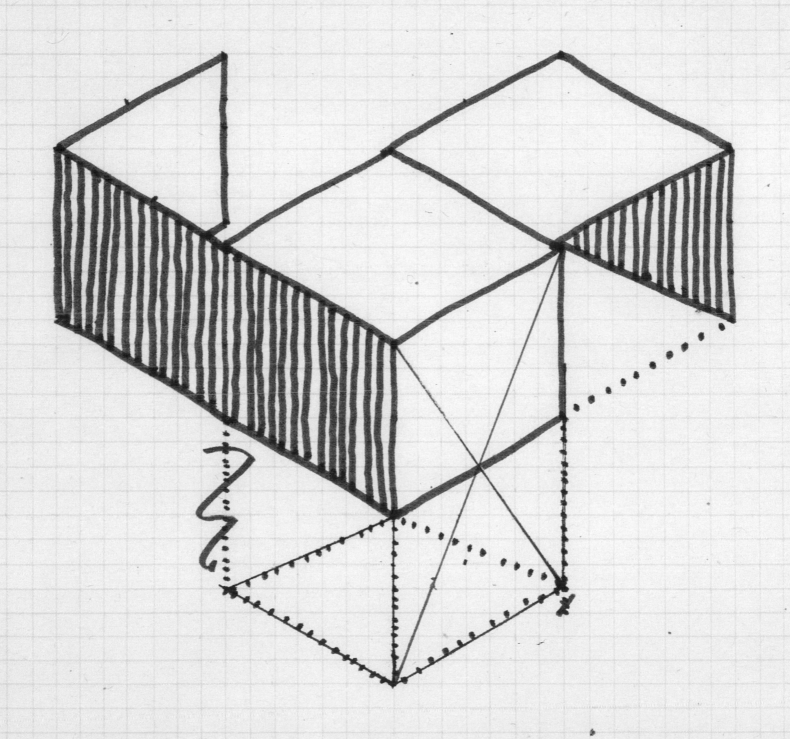

# Tony Smith

**Untitled**, 1963, Oil on canvas, 24 x 30 in. 61 x 76.2 cm.

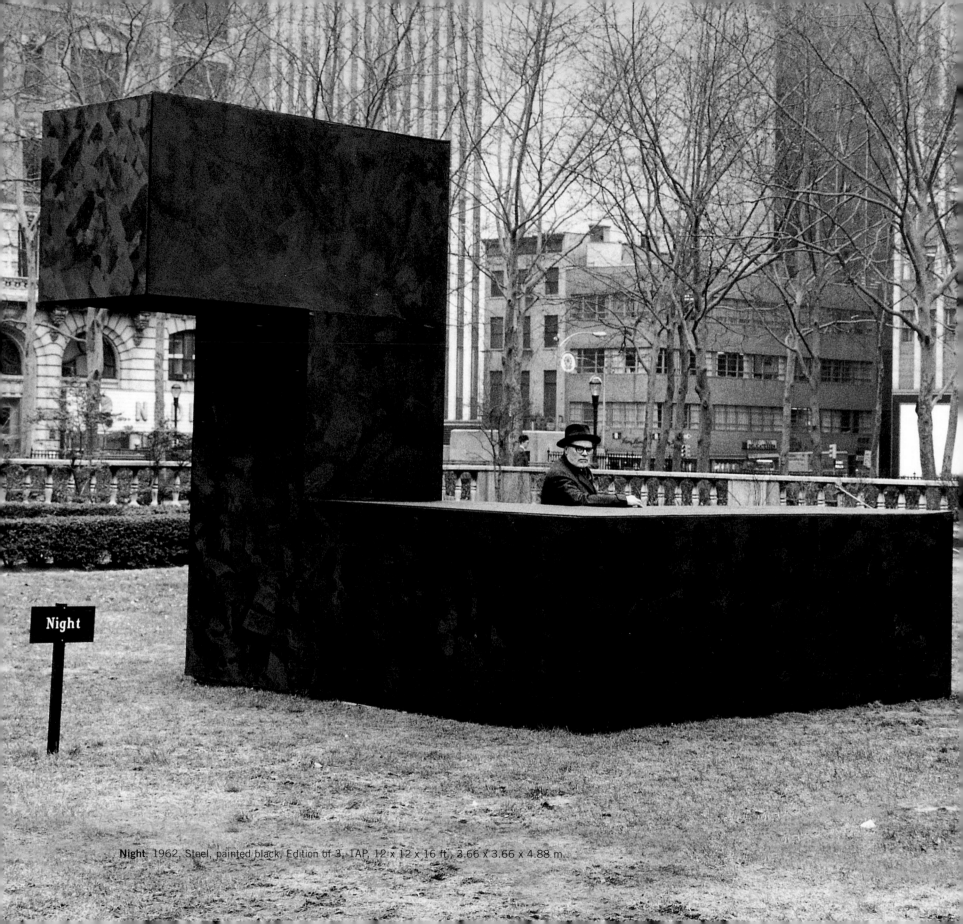

**Night**, 1962, Steel, painted black, Edition of 3, 1AP, 12 x 12 x 16 ft, 3.66 x 3.66 x 4.88 m.

# Tony Smith

## Paintings and Sculpture 1960-65

April 26 – June 23, 2001

Introduction by Richard Tuttle

Mitchell-Innes & Nash, New York

In collaboration with Matthew Marks Gallery, New York

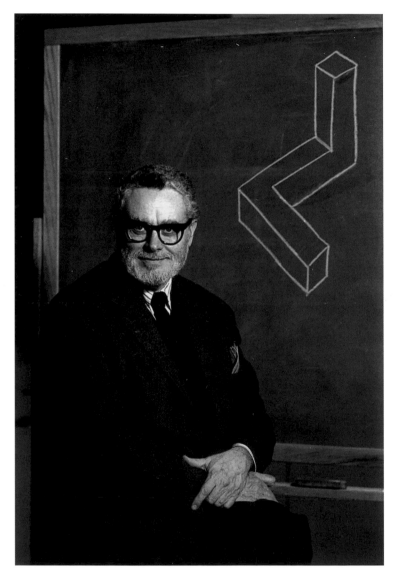

Tony Smith seated in front of a blackboard drawing of *Free Ride* in 1967.
Photo by David Gahr.

# From Some Source

Not wanting to write about the Past, I thought what can be the Future of Tony Smith, an artist offering many suggestions, dimensions, modulations which only reveal themselves over time. A nod of the head, an arm rested a certain way, such would reveal a thought pattern or development, rare, to be savored, remembered. One such sense was a certain momentum cars have when in forward motion.

There is the mass of the car—any car, perhaps, but with Tony one would think of an original car, perhaps the Silver Ghost he drove as a teenager to Georgetown University, which may have been all cars, forever, to him. This is significant for showing us how his brain worked, a peculiarly sensitive organ to a particularly sensitive mass, such that mass might have full meaning, though little substance—a maddeningly Irish version of things

concrete. Tony, an American of unusual awareness, brought charged inquisitivities to a world of mass so responsive that mass became a vehicle for every and almost any expression.

This did not complete things, as the car, which is the car of Stieglitz's O'Keeffe photos and Namuth's Pollock photos, transformed into the peculiar kind of mass *Die* is: something which had to move. I always thought of those high school physics equations where one considered how much energy it took a weight to move into the space in front of it, just as Tony would elevate high school mechanical drawing into high art, eventually. Tony was interested in how much the space in front was waiting, receptive, even characterized by what was about to fill it. Many transformations were halted in achieving one of his forms, like a poet would achieve a certain kind of poem by not

allowing this or that, hence, the reductive with Tony is not inside. He shares the problem/solution of reduction with the minimalists, but his was not a reaction to expressionism: he showed us a bridge. To name that bridge is one of the purposes of this essay. Master of time (timing), he may have used this bridge for formative purposes. Look how many of his sculptures are bridges.

To me, one of the best bridges is *Wall*, 1964 (8 x 18 x 2 ft.). Closely investigated, it is so many bridges in one that it doesn't look like a bridge at all, though it is next to a "wall."

Unlike waiting for a bus, where you wait from a certain time until the bus comes, and because art is always contemporary, you wait from now, looking toward the future. When the moment you have waited for arrives, becomes contemporary, you see the future of it—this is true whether in the work or the artist. With certain artists, you wait—even though unaware of it—for a moment when something in their work will become clear. This is a time when a separation of what is appropriate to the last century and what is appropriate to this, becomes apparent. Tony was not one who was going to accept his historical position: he was a student of what his situation actually was. He needed thrust to find "out." Things like momentum, velocity, weight and counterweight, a part of the phenomenology which fascinated his generation, all interested him, and he could bring them all together and use them, not only in his work, but as in his appreciation of his friends and their art. This is how he loved Agnes Martin's rectangle paintings (1958), one of which he proudly brought home to his young family. He understood how the natural was underdeployed.

How does one understand weight and volume? The modernist did so by penetrating it, but Tony did it by changing it to mass—to signal this heavy black car underbody paint was used to slather over the mass (as outlined form). This doubling, only reached by passion in need, is what originally took my breath away and convinced me of all that was modern (meaning "new"), what hadn't been pierced, setting the stage for all else. How were we part—even disembodied—of something and nothing? In an age when the body functions as critique of technology, what happens when the body doesn't function?—wonderful things! Pieces of the body can connect with other things, and they can connect among themselves to create forms while making better critiques which we didn't know before.

Enough said about mass. Where is the car going? Into what? A complete unknown? Certainly not into Tony himself. Even though he painted himself in glamour, he knew it was not the appropriate glamour. Nor was the space known by the mass which would fulfill it. This was not a futurist's game; his concern was genuine. A man who could recite pages of Joyce was not in the least affected by it, though it would be good to triangulate the three Irish men, Joyce, Beckett, and Tony, to complete a circle. The effect of momentum on the space—this had promise, but wasn't the issue more like prolonging the moment of definition to keep it free, American?

The car becomes mass; the mass becomes space. What space? The space filled with mass? Not quite. Peculiar edges. No give-away edges. But the space of the sculptures—an artificial.

Richard Tuttle

February, 2001

Plates

**Cigarette**, 1961
15ft. 1in. x 25ft. 6in. x 18ft. 7in.   4.6 x 7.77 x 5.66 m.
This sculpture is fabricated in steel and painted black in an
edition of three with one artist's proof. The sculpture 1/3
was fabricated in Cor-ten steel.

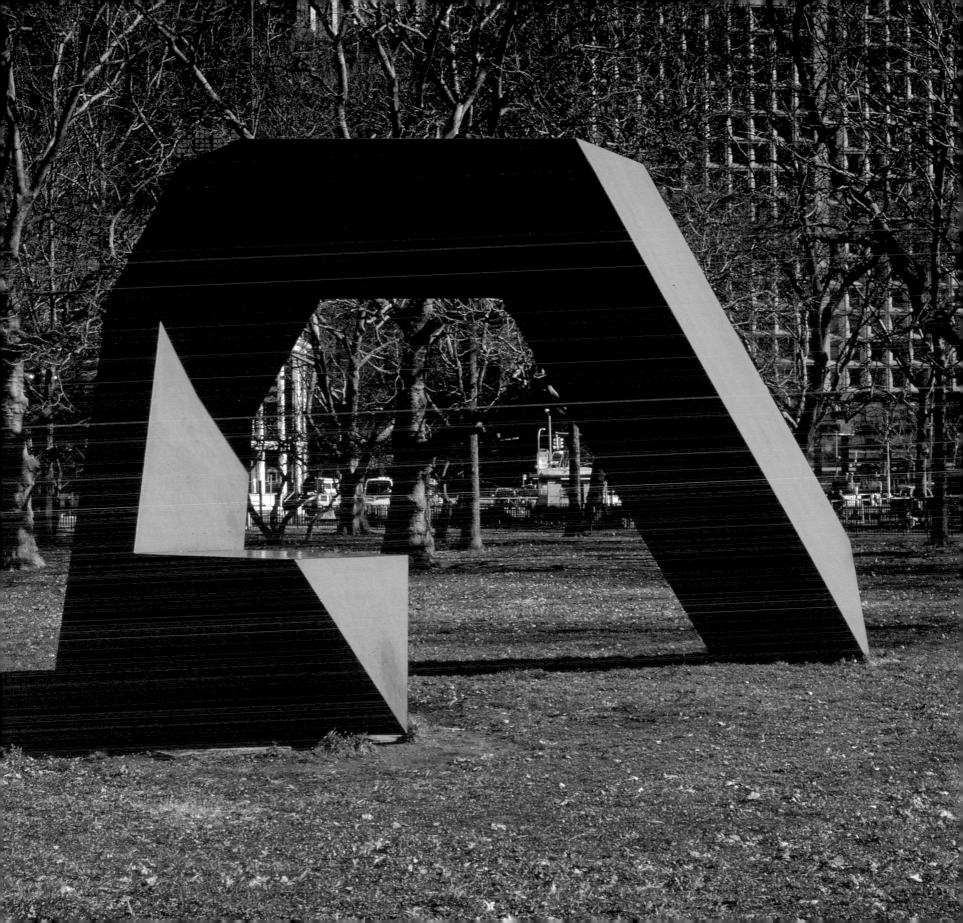

**Untitled**, 1962-63
Oil on canvas
47 x 59 in.   119.4 x 149.9 cm.

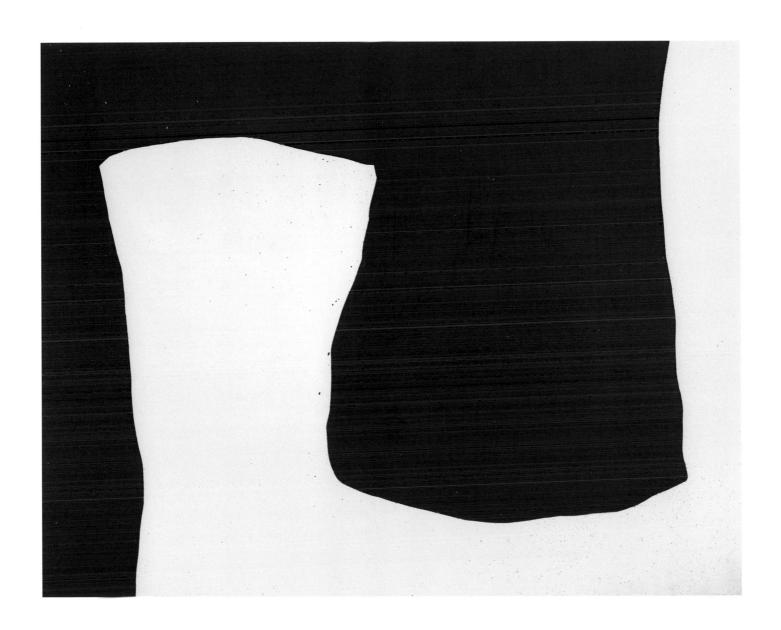

**Marriage**, 1961

10 x 10 x 12 ft.   3.05 x 3.05 x 3.66 m.

This sculpture is fabricated in steel and painted black
in an edition of three with one artist's proof.

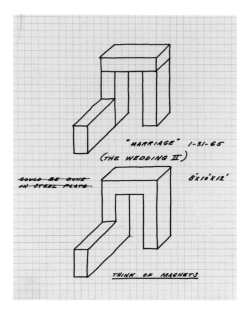

**Marriage**, 1965, Ink on paper

11 x 8 1/2 in.  27.9 x 21.6 cm.

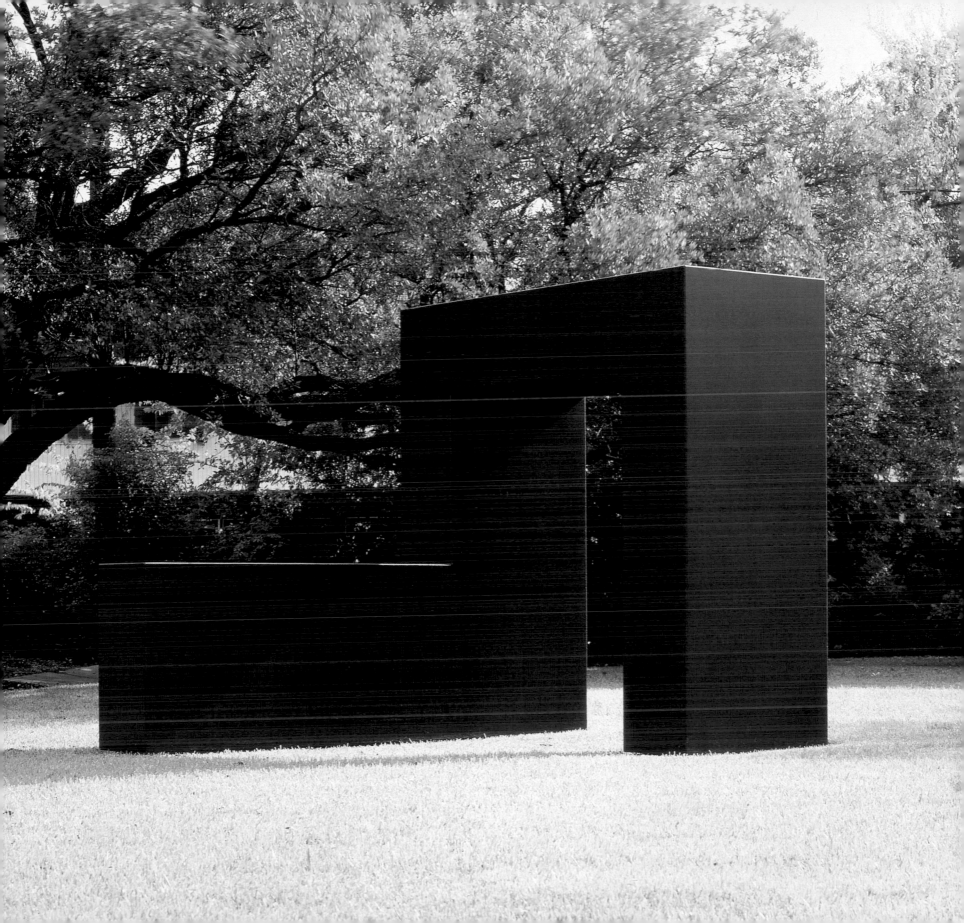

**Free Ride**, 1962

6ft. 8in. x 6ft. 8in. x 6ft. 8in.   2.03 x 2.03 x 2.03 m.

This sculpture is fabricated in steel in an edition of three with one artist's proof. The sculptures 1/3 and 2/3 have an oiled finish; 3/3 and the artist's proof are painted black.

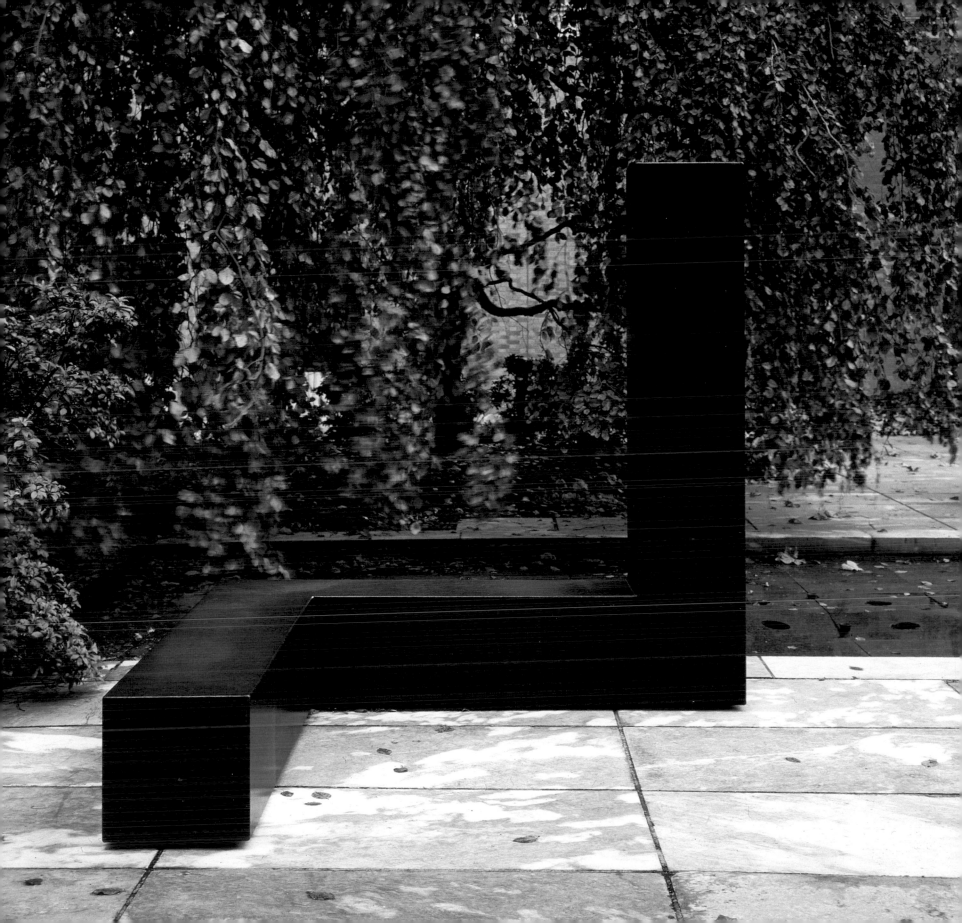

**Untitled**, 1962
Oil on canvas
64 x 94½ in.   162.6 x 240 cm.

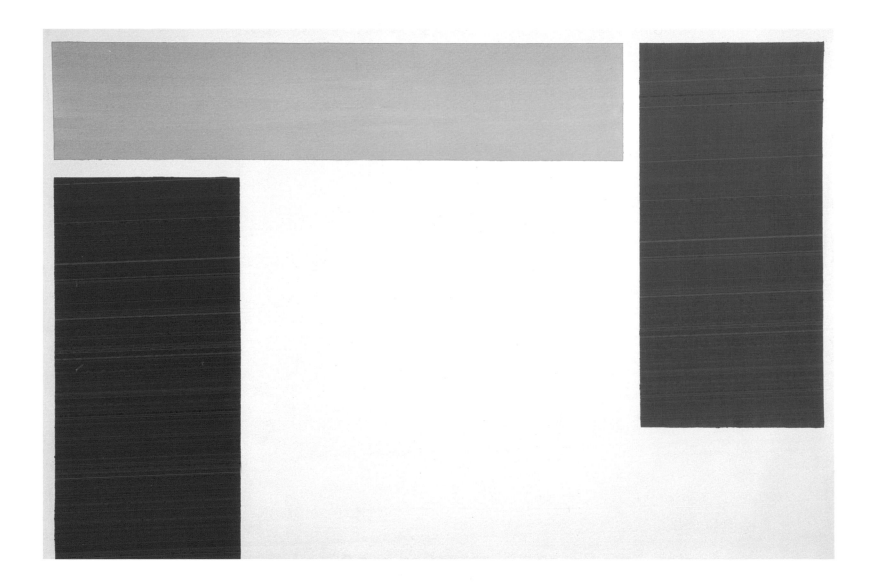

**Untitled**, 1962-63
Oil on canvas
24 x 36 in.   61 x 91.4 cm.

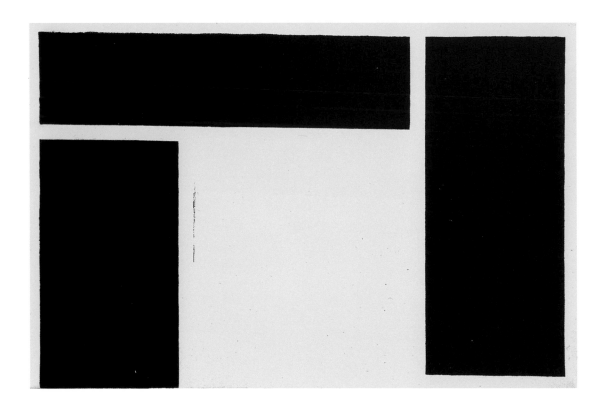

**Untitled**, 1962-63
Oil on canvas
24 x 36 in.   61 x 91.4 cm.

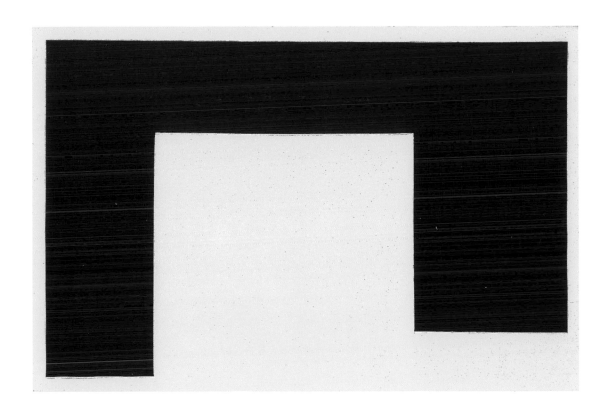

**Untitled**, 1962-63
Oil on canvas
47 x 59 in.   119.4 x 149.9 cm.

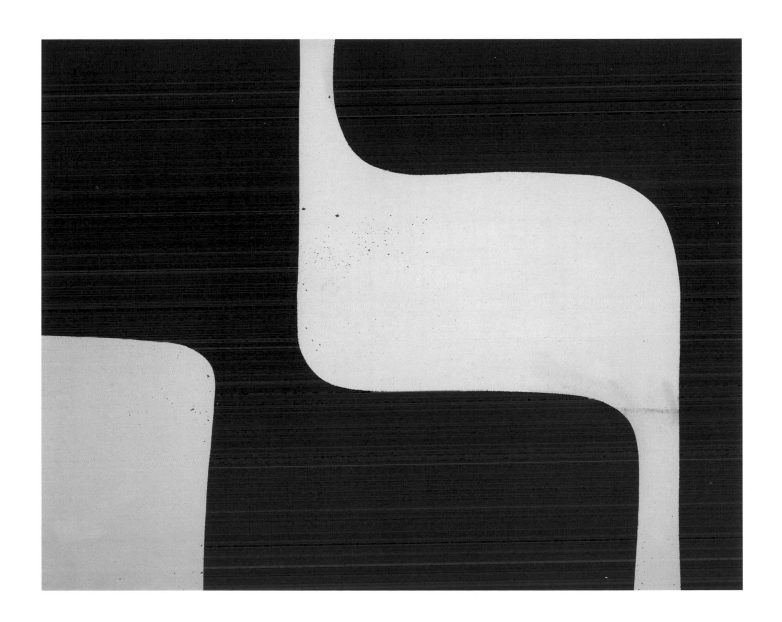

**Untitled**, 1961
Oil on canvas
48 x 60 in.   121.9 x 152.4 cm.

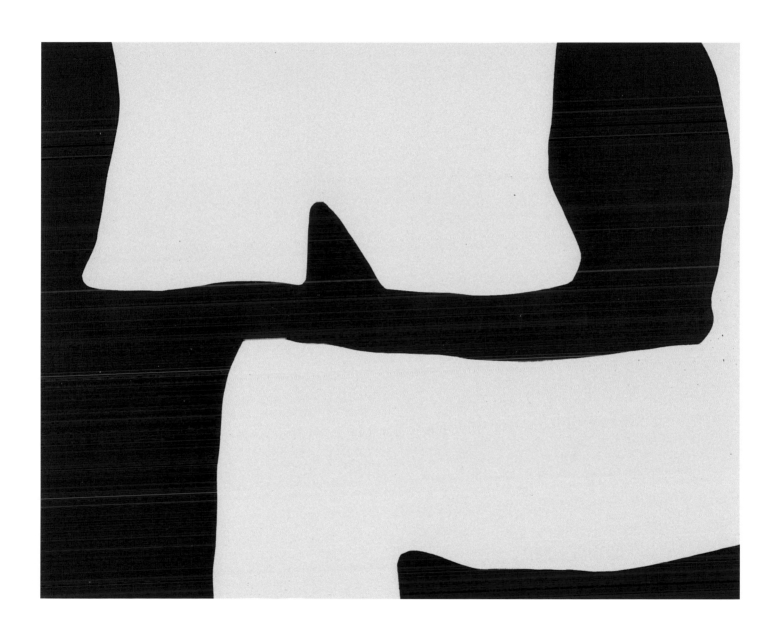

**Beardwig**, 1962

42 x 36 x 36 in.   106.7 x 91.4 x 91.4 cm.

This sculpture is fabricated in steel and painted black
in an edition of six with one artist's proof.

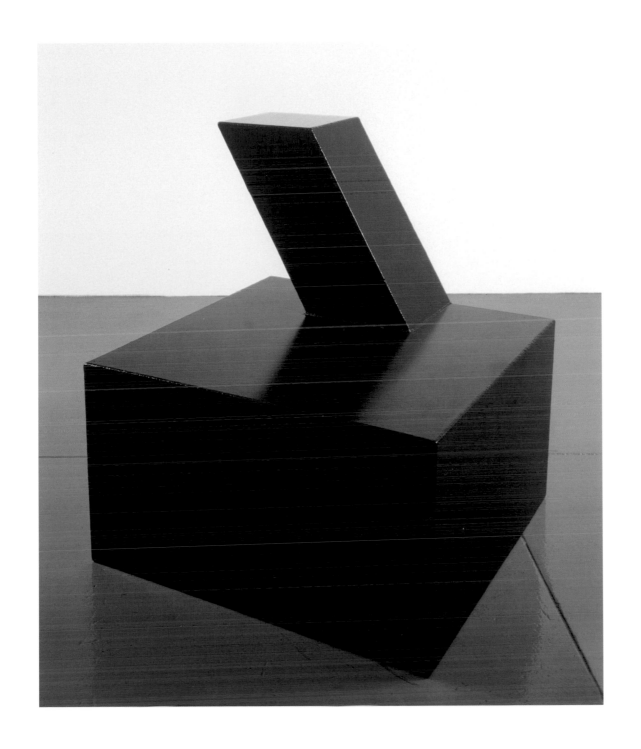

**Untitled**, 1962-63
Oil on canvas
42 x 48 in.   106.7 x 121.9 cm.

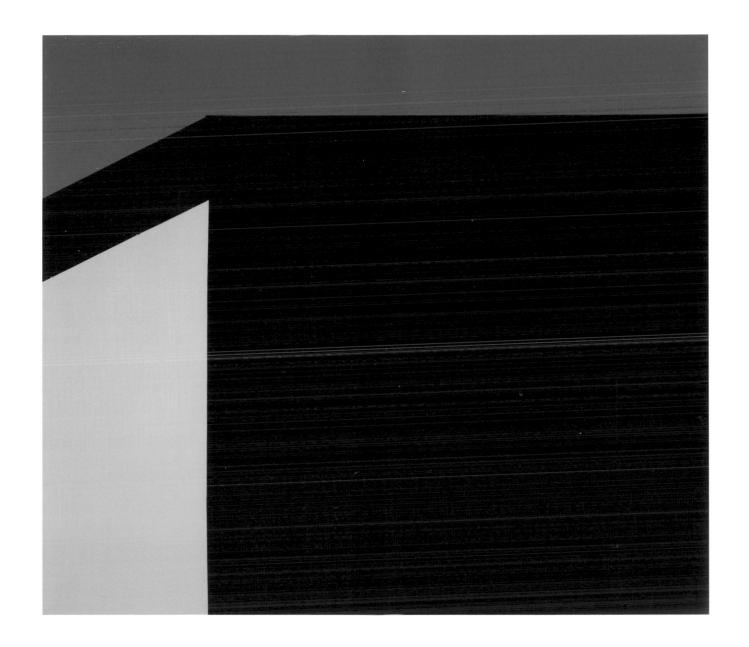

**Black Box**, 1962

22½ x 33 x 25 in.   57.2 x 83.8 x 63.5 cm.

This sculpture is fabricated in steel with an oiled finish
in an edition of three with one artist's proof. The artist's
proof was fabricated in Cor-ten steel.

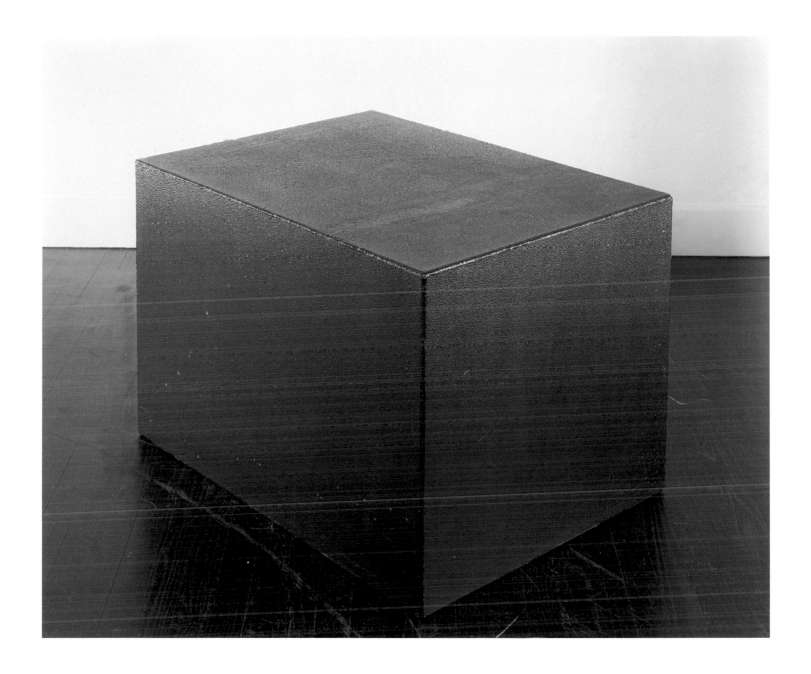

**Die**, 1962

6 x 6 x 6 ft.   1.83 x 1.83 x 1.83 m.

This sculpture is fabricated in steel with an oiled
finish in an edition of three with one artist's proof.

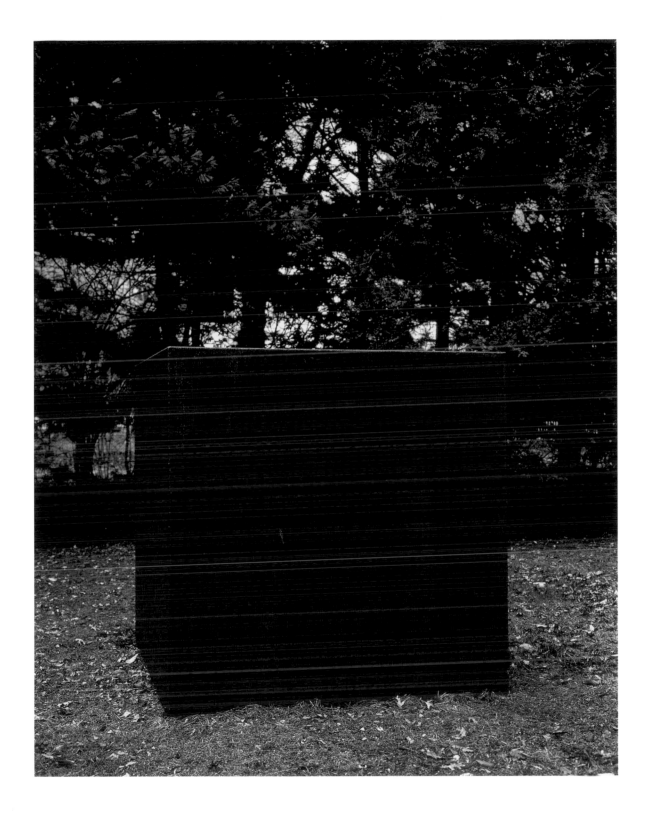

**Untitled**, 1961-62
Oil on canvas
24 x 30 in.   61 x 76.2 cm.

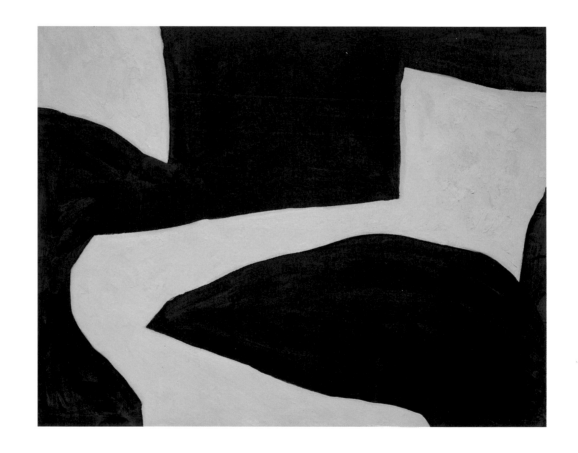

**Mistake**, 1963
12 x 12 x 8 in.   30.5 x 30.5 x 20.3 cm.
This sculpture is cast in bronze with a black patina
in an edition of nine with one artist's proof.

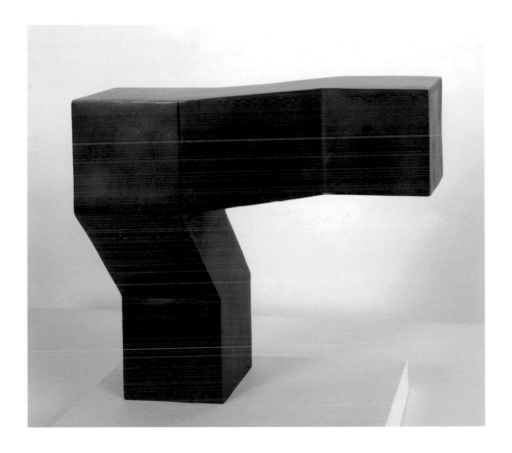

**Cross**, 1960-62

32 x 32 x 32 in.   81.3 x 81.3 x 81.3 cm.

This sculpture is cast in bronze with a black patina

in an edition of six with one artist's proof.

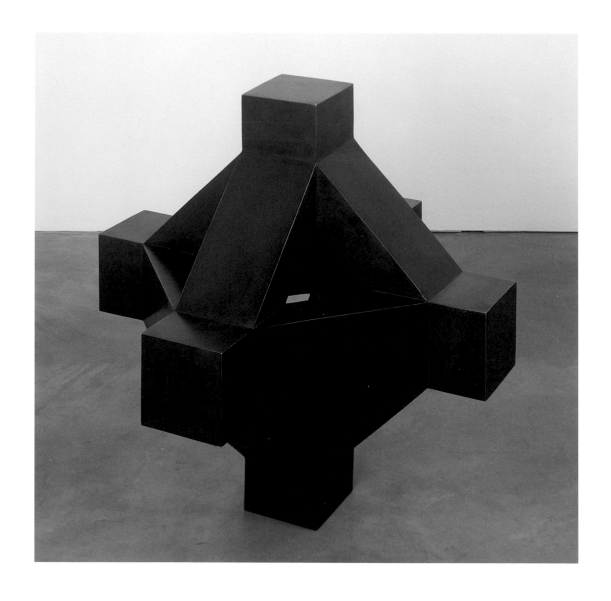

**Tower of the Winds**, 1962

33 x 33 x 33 in.   83.8 x 83.8 x 83.8 cm.

This sculpture is cast in bronze with a black patina in
an edition of six with one artist's proof.

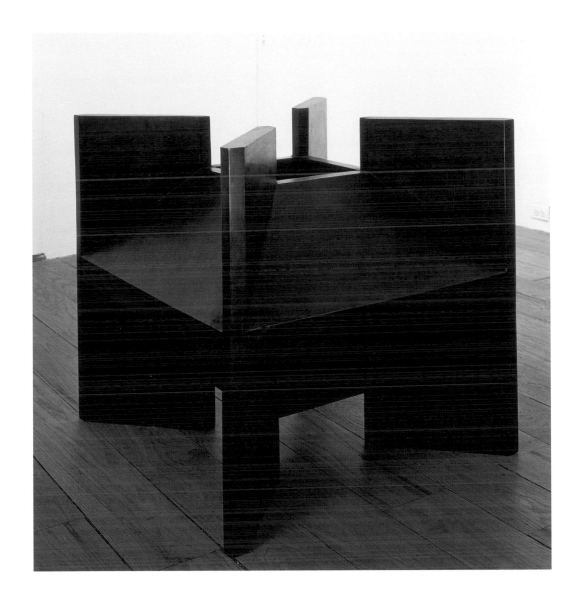

**Light Box**, 1961

26¼ x 20 x 22 in.   66.7 x 50.8 x 55.9 cm.

This sculpture is cast in bronze with a black patina in
an edition of nine with one artist's proof.

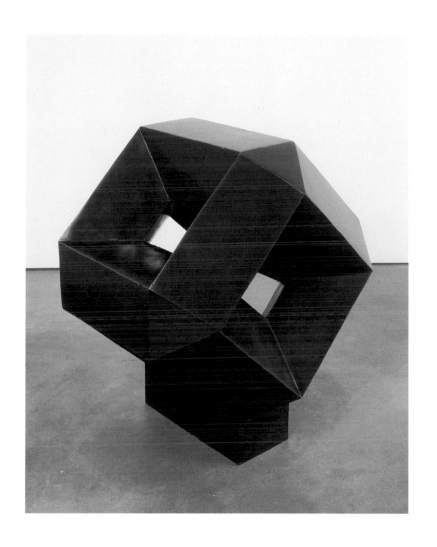
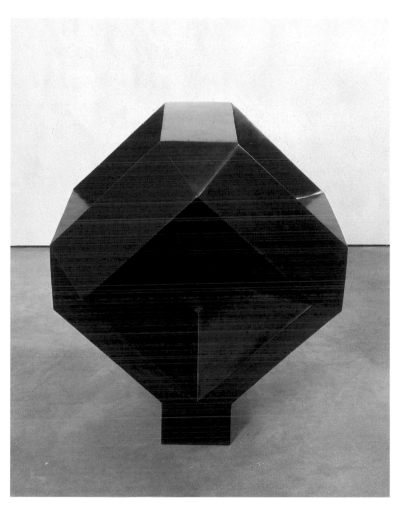

**Generation**, 1965

30 x 35½ x 35½ in.    76.2 x 90.2 x 90.2 cm.

This sculpture is cast in bronze with a black patina
in an edition of six with one artist's proof.

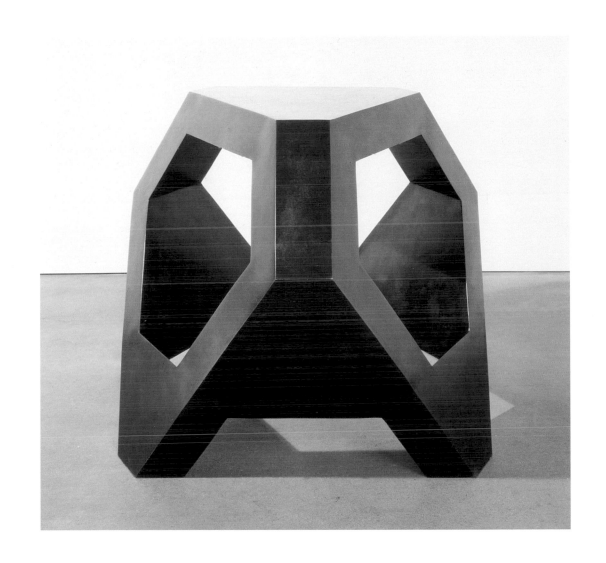

**Untitled**, 1962-63
Oil on canvas
48 x 60 in.   121.9 x 152.4 cm.

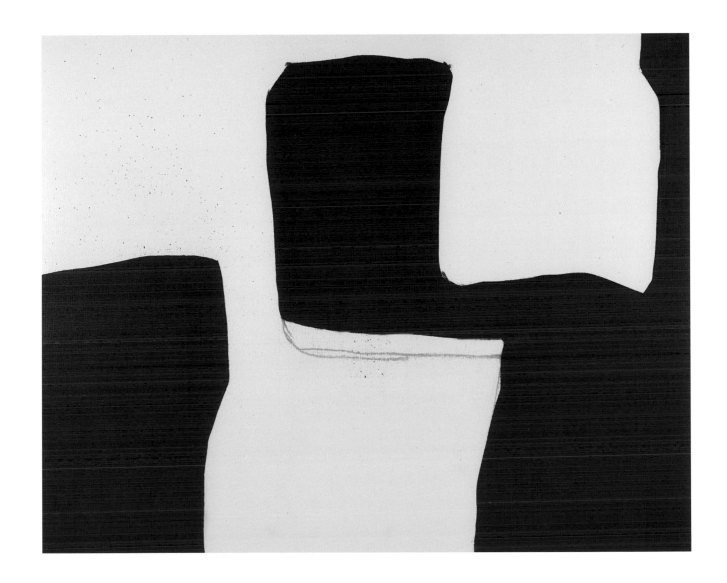

**The Keys to Given!**, 1965
16 x 16 x 16 in.   40.6 x 40.6 x 40.6 cm.
This sculpture is cast in bronze with a black patina
in an edition of six with one artist's proof.

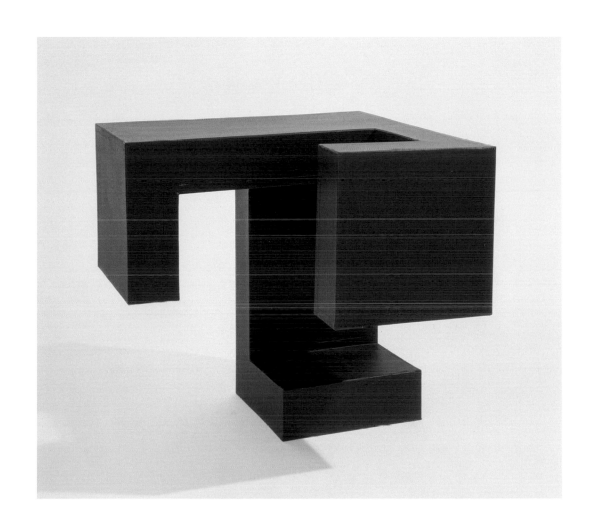

**Duck**, 1962-63

11ft. 4in. x 13ft. 10in. x 9ft. 3in.   3.45 x 4.22 x 2.82 m.

This sculpture is fabricated in steel and painted black in
an edition of three with one artist's proof.

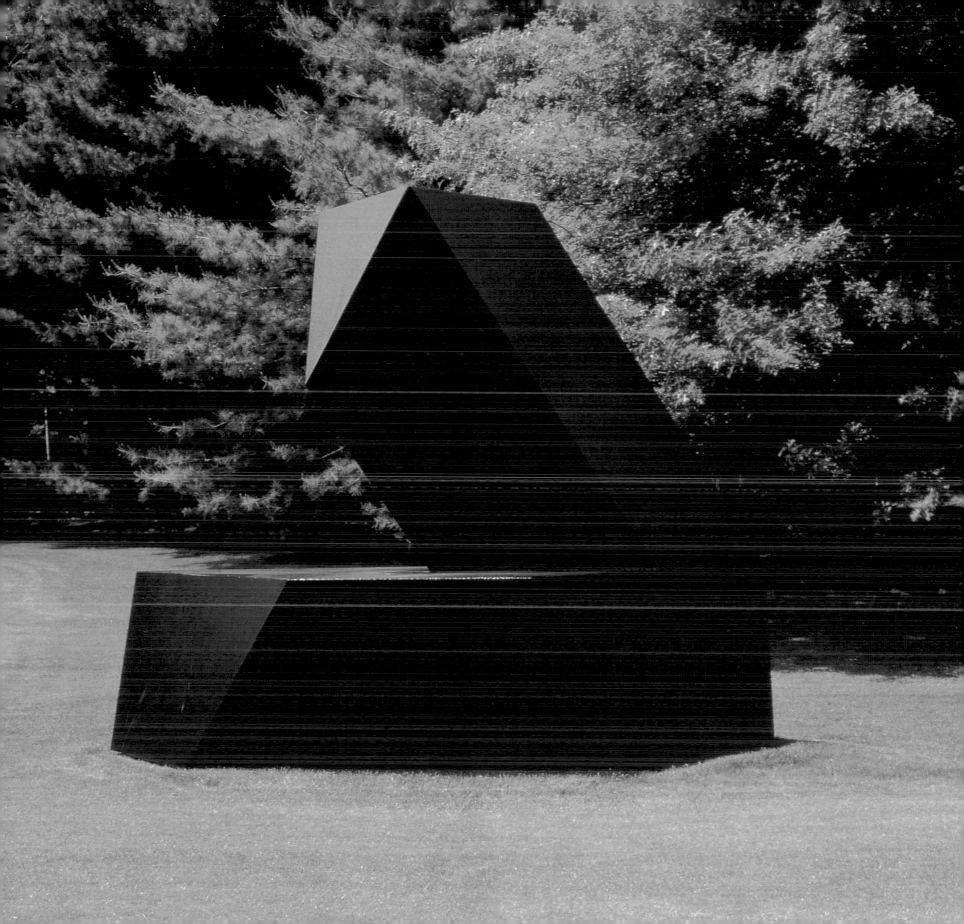

**Spitball**, 1961

11ft. 5in. x 14ft. x 13ft. 4½in.   2.87 x 4.27 x 4.08 m.

This sculpture is fabricated in steel and painted black

in an edition of three with one artist's proof.

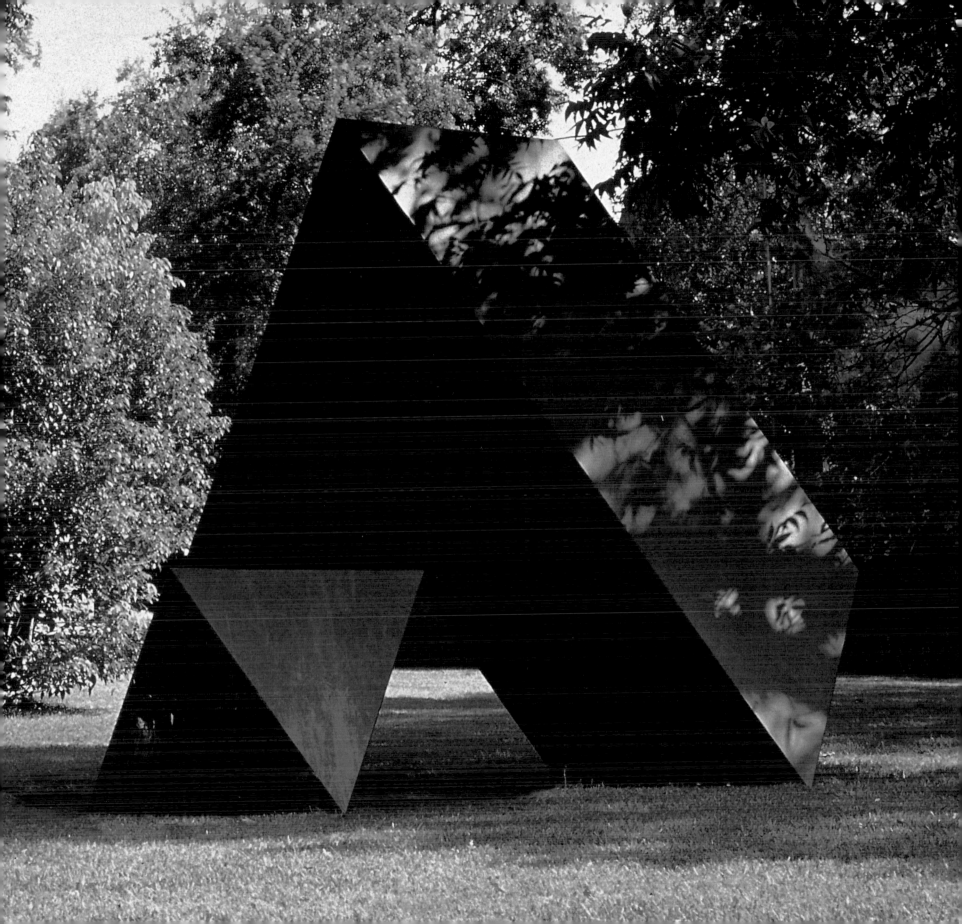

**Untitled**, *c.* 1961
Oil on canvas
30 x 24 in.   76.2 x 61 cm.

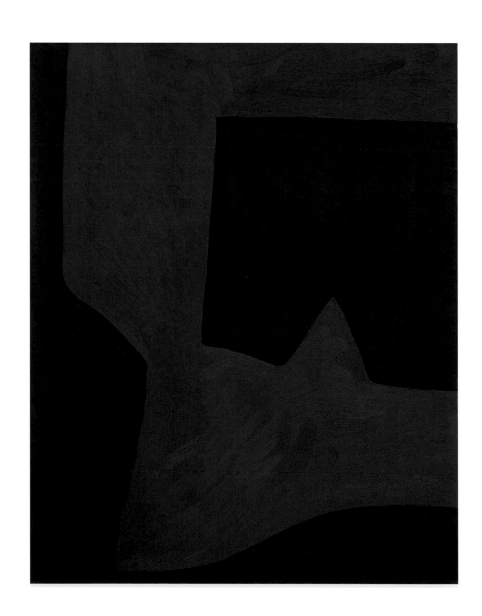

**Untitled**, *c.* 1961
Oil on canvas
24 x 30 in.   61 x 76.2 cm.

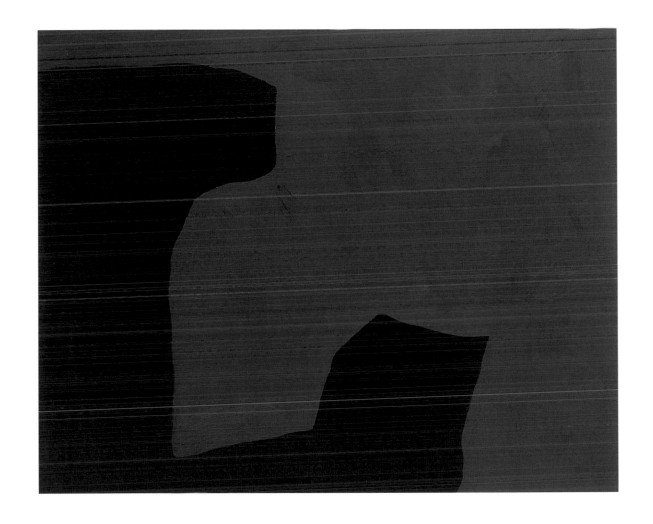

**Tau**, 1965

14ft. x 21ft. 6in. x 12ft. 4¼in.   4.28 x 6.55 x 3.77 m.

This sculpture is fabricated in steel and painted black in an edition
of three with one artist's proof.

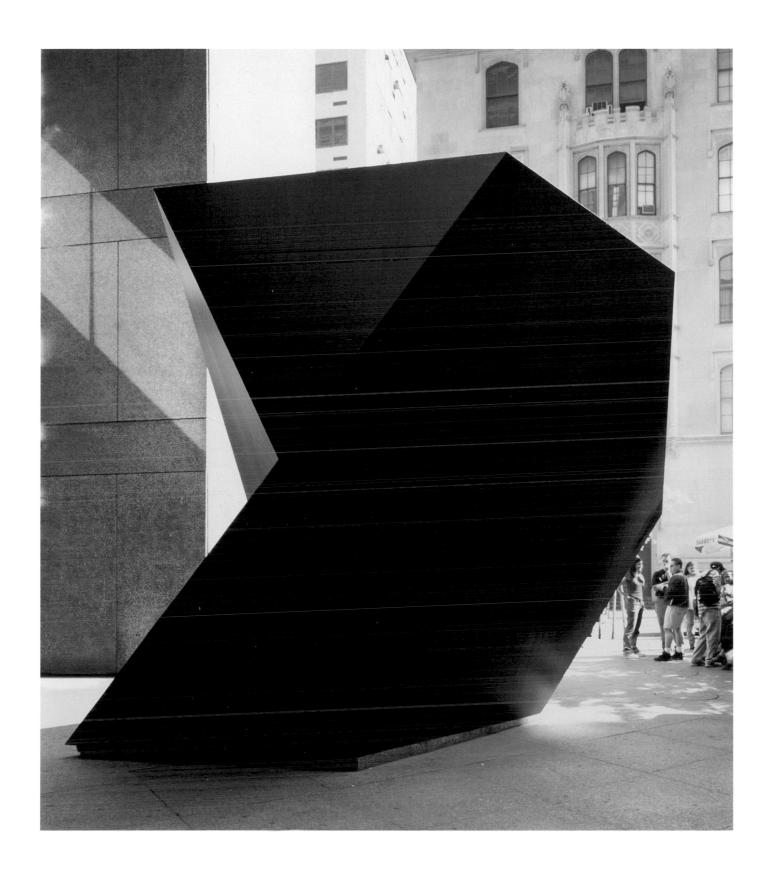

**Untitled**, 1961
Oil on canvas
47 x 59 in.   119.4 x 149.9 cm.

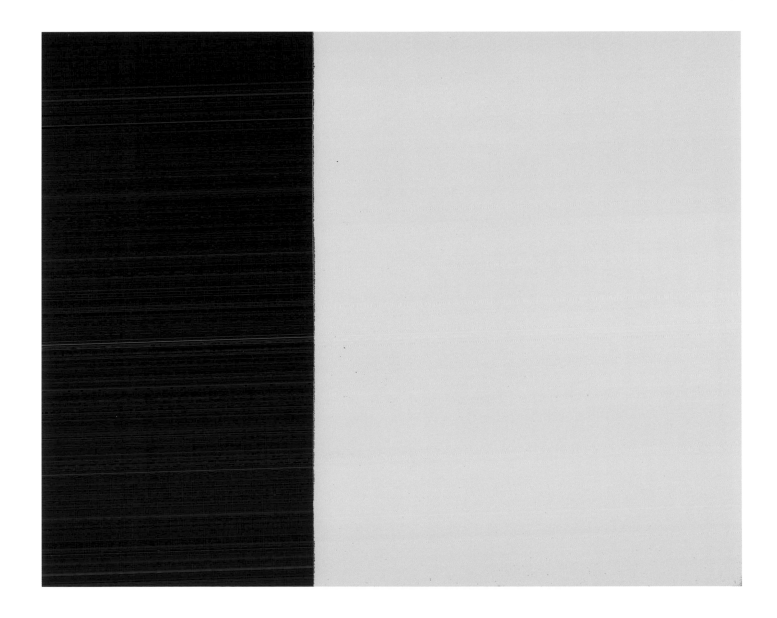

**Wall**, 1964

16 x 5¼ x 36 in.   40.6 x 13.3 x 91.4 cm.

This sculpture is cast in bronze with a black patina
in an edition of nine with one artist's proof.

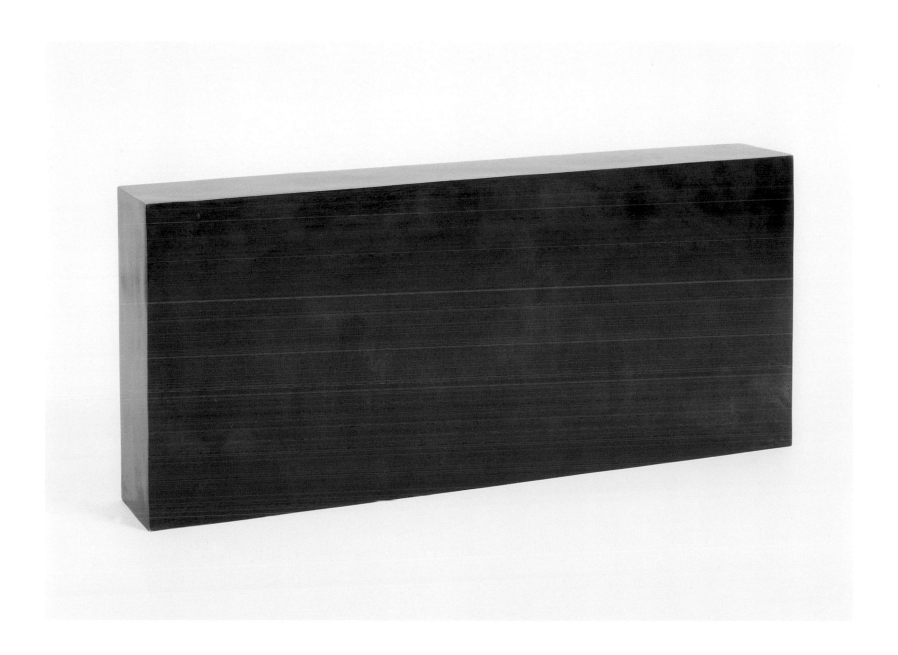

**Untitled**, 1962-63
Oil on canvas
24 x 36 in.   61 x 91.5 cm.

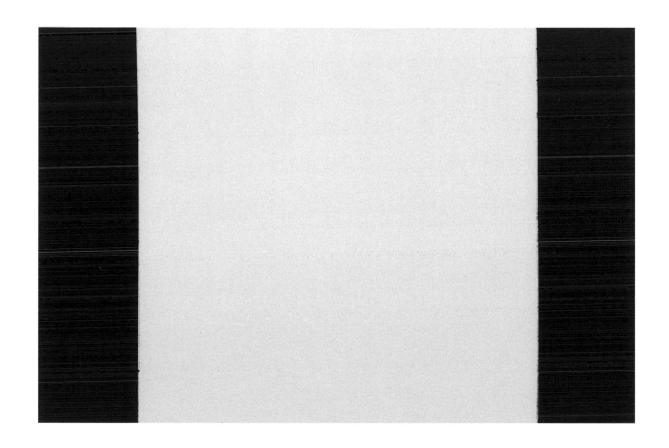

**The Elevens Are Up**, 1963

2 elements, each: 16 x 4 x 16 in.   40.6 x 10.2 x 40.6 cm.

Overall: 16 x 16 x 16 in.   40.6 x 40.6 x 40.6 cm.

This sculpture is cast in bronze with a black patina in an edition
of nine with one artist's proof.

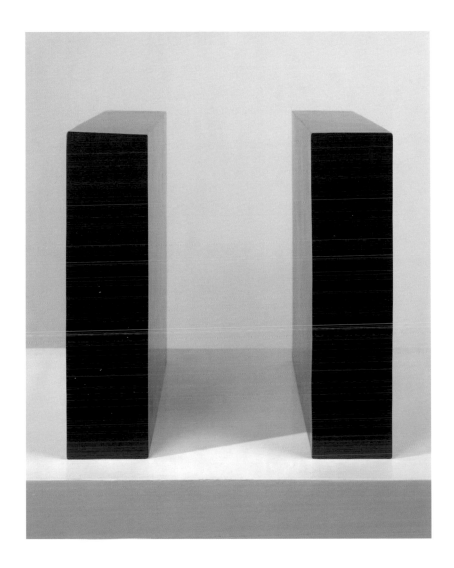

**We Lost**, 1962

18 x 18 x 18 in.   45.7 x 45.7 x 45.7 cm.

This sculpture is cast in bronze with a black patina
in an edition of nine with one artist's proof.

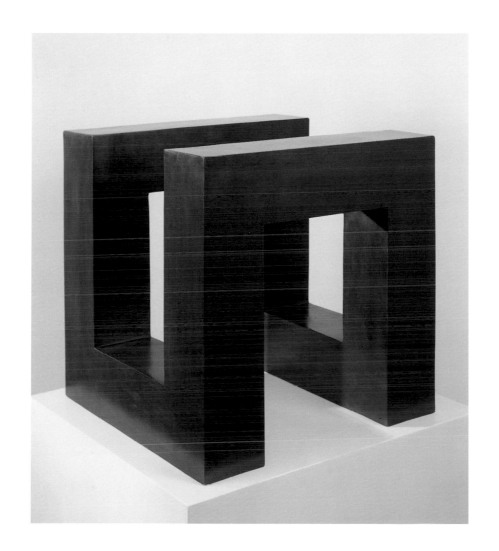

**Playground**, 1962

16 x 32 x 16 in.   40.6 x 81.3 x 40.6 cm.

This sculpture is cast in bronze with a black patina in
an edition of nine with one artist's proof.

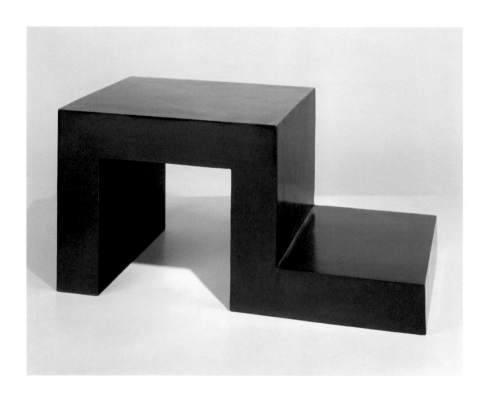

**Playground**, 1962

5ft. 4in. x 10ft. 8in. x 5ft. 4in.    1.63 x 3.25 x 1.63 m.

This sculpture is fabricated in steel and painted black in an edition

of three with one artist's proof.

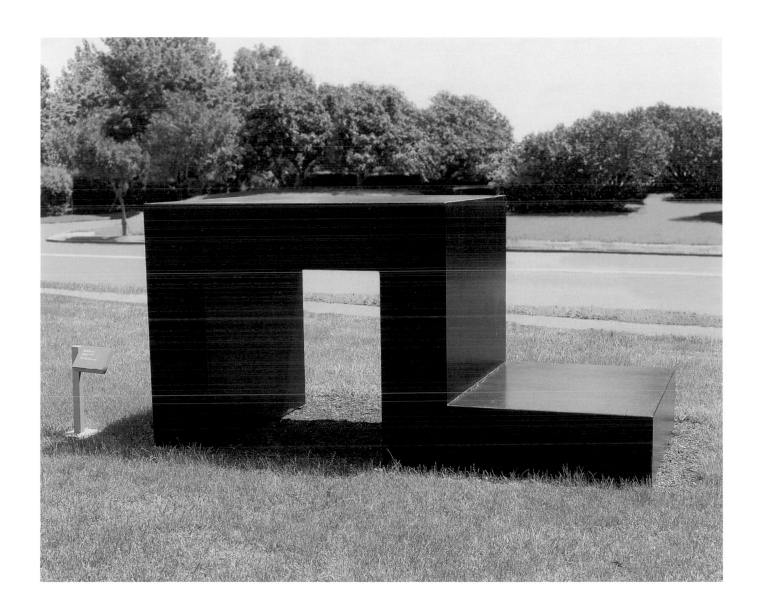

**Willy**, 1962

7ft. 7¼in. x 18ft. 8in. x 11ft. 3in.   2.32 x .57 x 3.43 m.

This sculpture is fabricated in steel and painted black in an edition
of three with one artist's proof.

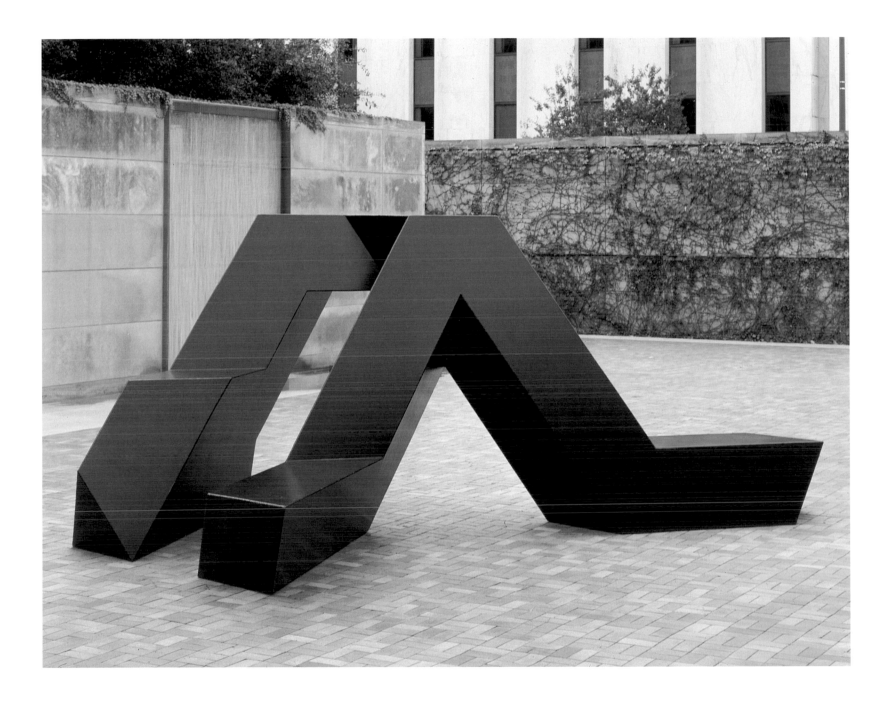

## PLATE ACKNOWLEDGEMENTS

Page 10, 11   *Cigarette*, The Museum of Modern Art, New York. Mrs. Simon
              Guggenhheim Fund

Page 14, 15   *Marriage*, The Menil Collection, Houston. Gift of the Menil Collection to the
              City of Oslo, Norway

Page 16, 17   *Free Ride*, The Museum of Modern Art, New York. Gift of Agnes Gund and
              Purchase

Page 46, 47   *Duck*, The Donald M. Kendall Sculpture Gardens at PepsiCo, Inc.,
              Purchase, New York. Courtesy PepsiCo, Inc.

Page 48, 49   *Spitball*, The Menil Collection, Houston

Page 52, 53   *Tau*, Hunter College of the City University of New York

Page 65       *Playground*, Memorial Art Gallery of the University of Rochester: Gift of the
              Artist, and Marion Stratton Gould Fund, photo by James Via

Page 66, 67   *Willy*, Dallas Museum of Art, Irvin L. and Meryl P. Levy Endowment Fund
              and General Acquisitions Fund

This catalogue was published on the occasion of the exhibition
TONY SMITH: PAINTINGS AND SCULPTURE 1960-65
held at Mitchell-Innes & Nash, New York
April 26 – June 23, 2001
Presented in collaboration with Matthew Marks Gallery, New York

Publication © 2001 Mitchell-Innes & Nash
Introduction © 2001 Richard Tuttle

All works by Tony Smith © Tony Smith Revocable Trust/Artists Rights
Society, New York

Design: Dan Miller Design, New York
Printing: Oddi Printing Ltd., Reykjavik, Iceland

ISBN: 0-9660769-9-0

MITCHELL-INNES & NASH
1018 Madison Avenue New York, NY 10021 USA
Telephone 212-744-7400 Fax 212-744-7401
Email info@miandn.com Web www.miandn.com

MATTHEW MARKS GALLERY
523 West 24th Street New York, NY 10011 USA
Telephone 212-243-0200 Fax 212-243-0047
Email gallery@mmarks.com

Mitchell-Innes & Nash and Matthew Marks Gallery are very pleased to present
this catalogue, and the exhibition which it accompanies, as our first
collaboration on behalf of our new representation of the Estate of Tony Smith.

We are deeply indebted, first and foremost, to Jane Smith, Kiki and Seton
Smith and Sarah Auld, of the Tony Smith Estate. Their insight into the
paintings and sculpture of Tony Smith helped provide the initial inspiration
for the show. It has been our great pleasure working with them and we very
much look forward to all our future projects.

We would also like to offer our special thanks to John Silberman, the attorney
for the Estate, and to Richard Tuttle, whose idea into Smith's work provides a
deeply personal introduction to our catalogue.

Finally, we would like to thank the Paula Cooper Gallery, whose past work
with the Estate provided us many essential images for this publication.

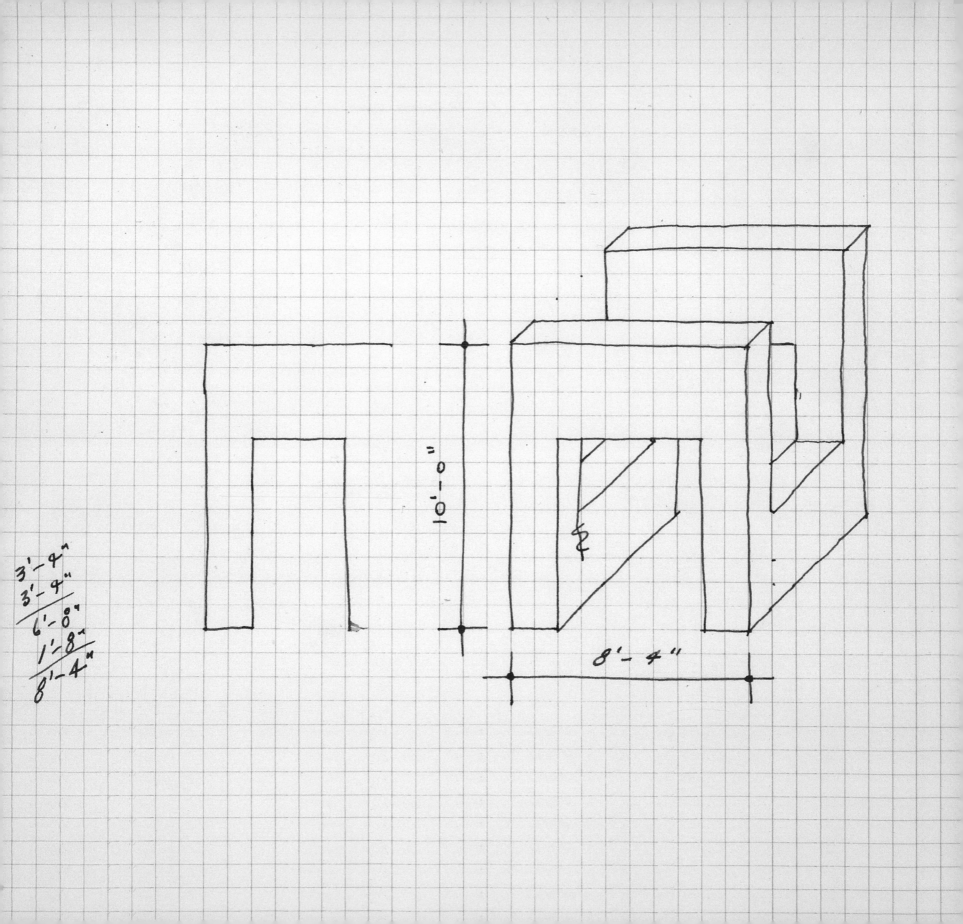

10'-0"

8'-4"

3'-4"
3'-4"
6'-0"
1'-8"
8'-4"